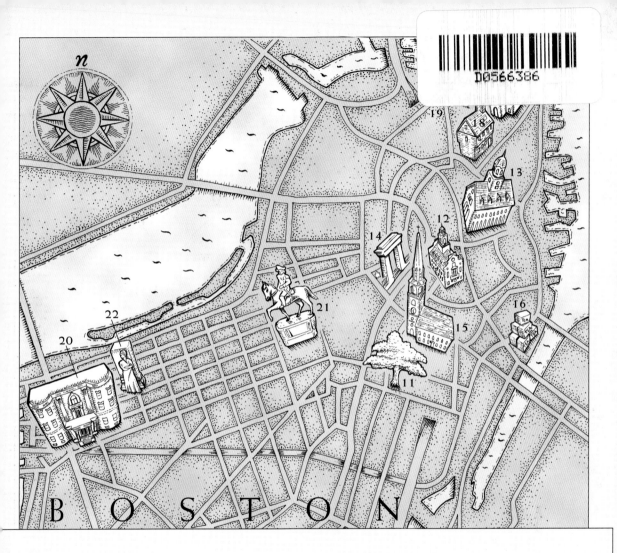

11. Site of Liberty Tree

12. Old State House

13. Faneuil Hall

14. Granary Burying Ground

15. Old South Meeting House

16. Site of Boston Tea Party

17. Old North Church

18. Paul Revere's House

19. Copps Hill Burying Ground

20. Mass. Historical Society

21. Statue of George Washington

22. Statue of Abigail Adams

ISBN-13: 978-1-889833-95-8
ISBN-10: 1-889833-95-9

Library of Congress Cataloging-in-Publication Data

Welsch, Ulrike.
 Revolutionary sites of Greater Boston / photographs by Ulrike Welsch ; text by Robert J. Allison.
 p. cm. — (The New England landmarks series)
 ISBN 1-889833-95-9
 1. Historic sites—Massachusetts—Boston Region—Pictorial works. 2. Boston Region (Mass.)—History, Local—Pictorial works. 3. Boston (Mass.)—History—Revolution, 1775–1783. 4. Boston (Mass.)—History—Revolution, 1775–1783—Quotations, maxims, etc. 5. United States—History—Revolution, 1775–1783—Quotations, maxims, etc. I. Allison, Robert J. II. Title. III. New England landmarks.
 F73.37.W454 2005
 973.3′44461′00222—dc22 2004029163

Cover and interior design by Peter Blaiwas, Vern Associates, Inc.
Maps on endpapers by Jeffrey M. Walsh.
Printed in Korea.

Ms. Welsch's photos of the line engravings by Daniel Chodowiecki on pages 8–9 and of the tea leaves in the glass bottle on pages 30–31 are used courtesy of the Massachusetts Historical Society. Her photo of the memorial plaque of Crispus Attucks on page 22 is included courtesy of the Bostonian Society, Old State House Museum.

Commonwealth Editions
266 Cabot Street, Beverly, Massachusetts 01915
www.commonwealtheditions.com

Visit Ulrike Welsch's archive of international photographs at www.ulrikewelschphotos.com.

The New England Landmarks Series
Cape Cod National Seashore, photographs by Andrew Borsari
Walden Pond, photographs by Bonnie McGrath
Boston Harbor Islands, photographs by Sherman Morss Jr.

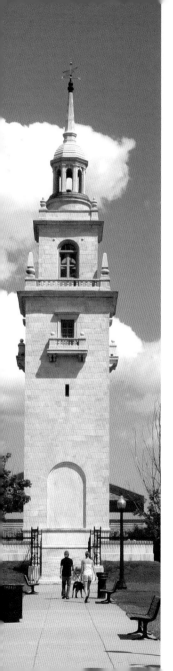

Revolutionary Sites
of Greater Boston

PHOTOGRAPHS BY ULRIKE WELSCH

Text by Robert J. Allison

COMMONWEALTH EDITIONS
Beverly, Massachusetts

What do we mean by the revolution?" John Adams wrote to Thomas Jefferson in 1815. "The war? That was no part of the revolution; it was only an effect and consequence of it. The revolution was in the minds of the people, and this was effected from 1760 to 1775 . . . before a drop of blood was shed at Lexington."

For most of the century, Massachusetts and the British Empire had a common interest. In the 1760s, however, these interests began to diverge. Massachusetts merchants grew wealthy by trading in the Caribbean and other North American ports; Parliament wanted to regulate this trade and tax the colonists—British subjects—to pay for the expanding empire. The Massachusetts Assembly insisted that only they, elected by the people of

Massachusetts, could tax the people of Massachusetts. "Taxation without representation," James Otis said, "is tyranny." If Parliament could tax the colonists, then Parliament would have complete control over the colonists.

Beginning in 1765, when Bostonians rioted to protest the Stamp Act, men and women risked their lives for the fundamental right to govern themselves. Forming the "Sons of Liberty," Boston's dockworkers, shoemakers, and other tradesmen gathered at the Liberty Tree to protest attempts by British authorities to control them. Mob violence increased, and in 1768 two regiments of British troops arrived in Boston to keep order in the increasingly troublesome town.

I AM BUT AN ORDINARY MAN.

The Times alone have destined

me to Fame.

—John Adams, Diary,

 April 16, 1779

John Adams's birthplace, Adams National Historical Park, Quincy

MAY WE EVER BE A PEOPLE FAVORED OF GOD!
May our land be a land of liberty, the seat of
virtue, the asylum of the oppressed, a name
and a praise in the whole earth, until the last
shock of time shall bury the empires of the
world in one common undistinguished ruin!

—Joseph Warren, March 5, 1772

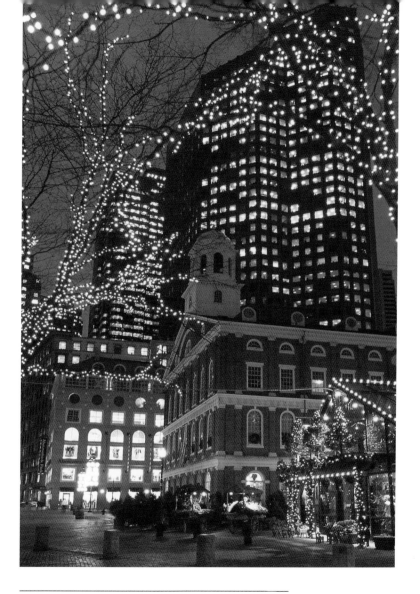

Faneuil Hall, dwarfed by Boston's modern office buildings

Line engravings by German-Polish artist Daniel Chodowiecki at the Massachusetts Historical Society, Boston, representing (*left to right*) reaction to the Stamp Act, the Tea Party, and the Battle of Lexington

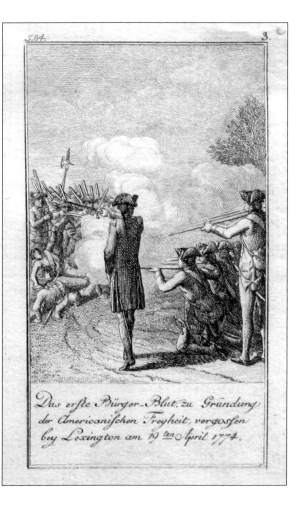

Das erste Bürger-Blut, zu Gründung der Americanischen Freyheit, vergossen bey Lexington am 19 ten April 1774.

THE END OF GOVERNMENT being the good of mankind points out its great duties: it is above all things to provide for the security, the quiet, and happy enjoyment of life, liberty, and property.

—James Otis, *The Rights of the British Colonies Asserted and Proved*, 1764

BENEATH, IN THE CHURCHYARD, LAY THE DEAD,

In their night-encampment on the hill,

Wrapped in silence so deep and still

That he could hear, like a sentinel's tread,

The watchful night-wind, as it went

Creeping along from tent to tent,

And seeming to whisper, "All is well!"

—Henry Wadsworth Longfellow,
 "Paul Revere's Ride," 1860

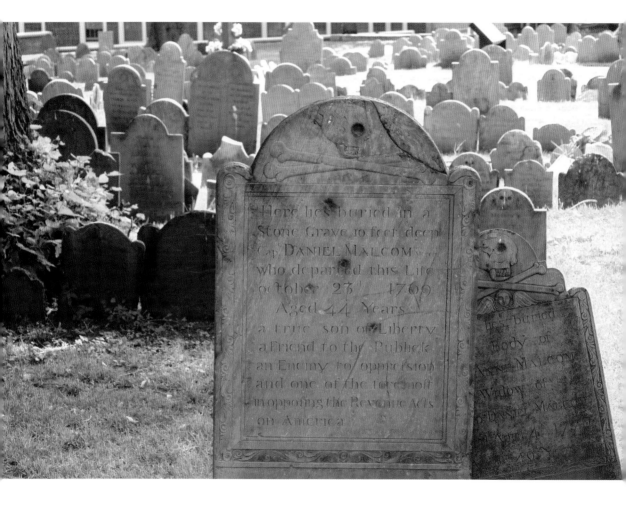

Gravestone of patriot Daniel Malcom, Copp's Hill Burial Ground, Boston, pocked with bullet marks of British target practice

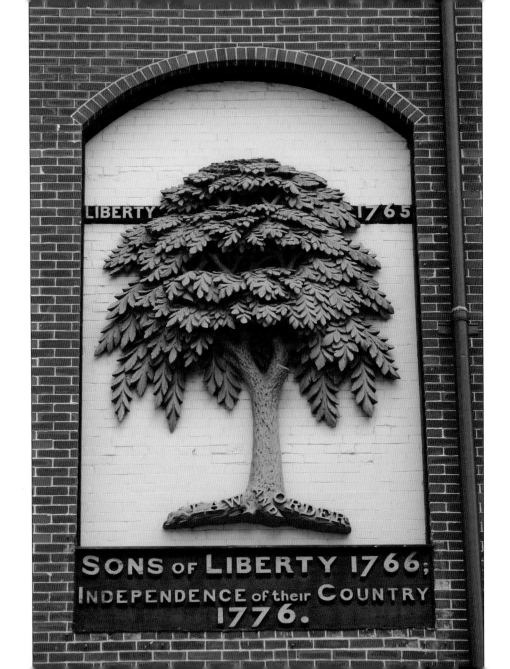

THE FAME OF ITS FRUIT DREW THE NATIONS AROUND,

To seek out this peaceable shore.

Unmindful of names or distinctions they came,

For freemen like brothers agree;

With one spirit endued, they one friendship pursued,

And their temple was Liberty Tree.

—Thomas Paine, "Liberty Tree," 1775

Plaque commemorating the Liberty Tree, Washington Street, Boston

Prominent Bostonians such as James Otis and Samuel Adams argued that 15,000 Bostonians did not need 2,000 British troops to keep order; the troops would only increase hostility toward British authority. Benjamin Franklin, Massachusetts' agent in London, wrote that the arrival of troops filled him with a "constant panic": he feared "the madness of mobs, or the interference of soldiers, or both, when too near each other, might occasion some mischief difficult to be prevented or repaired, and which might spread far and wide."

When violence flared in March 1770, leaving five Bostonians dead in what became known as the Boston Massacre, Samuel Adams prevailed

on the new governor, Thomas Hutchinson, to put seven soldiers on trial for murder, and send the rest to Castle Island in Boston Harbor. Adams organized a funeral for the dead—Crispus Attucks, James Caldwell, Samuel Gray, Samuel Maverick, and Patrick Carr—holding a memorial service at Faneuil Hall and carrying their bodies in a solemn procession through the streets, around the Liberty Tree, and finally to the Granary Burying Ground.

John Adams, Samuel's cousin, defended the accused soldiers. He wanted to show that the courts in Massachusetts could do justice even to men the community hated. Adams charged that the mob had provoked the soldiers; the jury acquitted all but two of them.

Site of the Boston Massacre in front of the Old State House, with "James Otis"

THE FATAL 5TH OF MARCH, 1770, CAN NEVER be forgotten; the horrors of that dreadful night are but too deeply impressed on our hearts; language is too feeble to paint the emotion of our souls, when our streets were stained with the blood of our brethren—"

—Joseph Warren, March 5, 1772

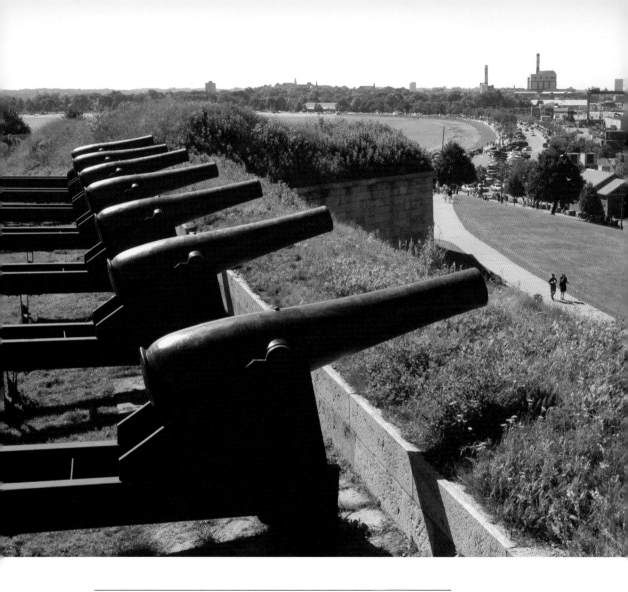

Site of the British fort on Castle Island, where cannons watched over the city

OUR STREETS ARE AGAIN FILLED
with armed men; our harbor
crowded with ships of war. But
these cannot intimidate us; our
liberty must be preserved; it is
far dearer than life. . . .

—Joseph Warren,
 March 6, 1775

PLEASE GOD, OUT OF THIS NEW ENGLAND SOIL such men would forever rise up ready to fight when need came. The one generation after the other. . . .

—Esther Forbes, *Johnny Tremain:*
 A Story of Boston in Revolt, 1943

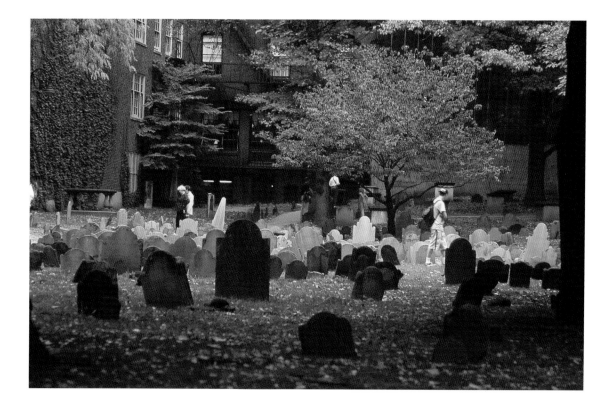

Boston's Granary Burying Ground, final resting place of the victims of the Boston Massacre, among others

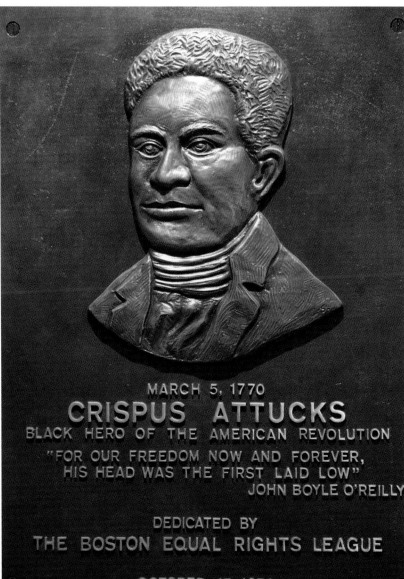

MARCH 5, 1770
CRISPUS ATTUCKS
BLACK HERO OF THE AMERICAN REVOLUTION
"FOR OUR FREEDOM NOW AND FOREVER,
HIS HEAD WAS THE FIRST LAID LOW"
JOHN BOYLE O'REILLY

DEDICATED BY
THE BOSTON EQUAL RIGHTS LEAGUE

OCTOBER 17, 1976

NOT THE BATTLE OF LEXINGTON OR BUNKER'S HILL, not the surrender of Burgoyne or Cornwallis, were more important events in American history than the Battle of King Street, on the 5th of March, 1770.

—John Adams, January 5, 1815

Plaque commemorating Crispus Attucks, Bostonian Society, Old State House Museum

oston was relatively quiet in the year after the Massacre. The British Governor, Thomas Hutchinson, noted that "were it not for an Adams or two" Boston would be a peaceful place. But in 1773 Parliament passed the Tea Act, giving the British East India Company a monopoly on all tea sold in the British Empire, mandating a tax on the tea, and designating a few select merchants in each port—including Thomas Hutchinson's two sons—to sell the tea.

"Methinks that in drinking Tea," wrote Benjamin Franklin, "a true American, reflecting that by every Cup he contributed to the Salaries, Pensions, and Rewards of the Enemies and Persecutors of his Country, would be half choak'd at the Thought, and find no quantity of Sugar sufficient to make the nauseous Draught go down."

When three ships loaded with East India tea arrived in November 1773, the Sons of Liberty prevented them from unloading their cargo. Governor Hutchinson insisted that the ships could not leave without unloading. Samuel Adams called public meetings, which grew so large and boisterous they overflowed Faneuil Hall and had to move to the Old South Meeting House.

After Hutchinson refused to allow the ships to sail, men dressed as Mohawk Indians boarded the tea ships and dumped the tea (valued today at over $1.2 million) into the harbor. In retaliation, Parliament suspended the Massachusetts Assembly and town meetings, replaced Hutchinson with General Thomas Gage, and closed Boston Harbor. Massachusetts would be forced to submit to Parliamentary rule.

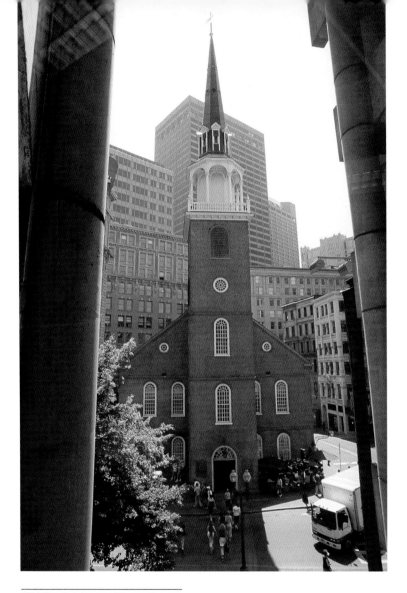

Old South Meeting House, Boston

THIS DESTRUCTION OF THE TEA
is so bold, so daring, so firm,
intrepid and inflexible, and
it must have so important
Consequences, and so lasting,
that I cant but consider it as
an Epocha in History.

—John Adams, Diary,
 December 17, 1773

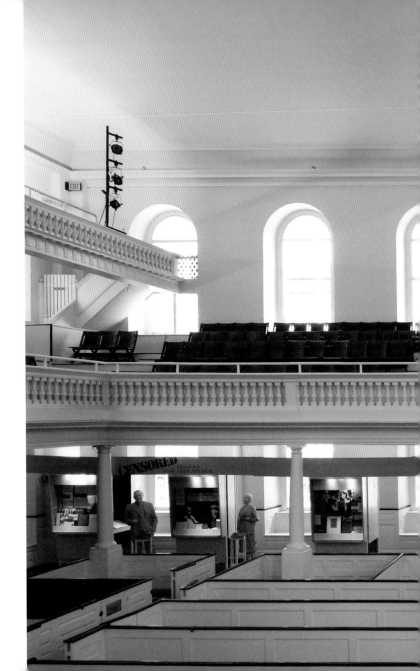

Interior of Old South
Meeting House, where
final plans were made
for the Tea Party

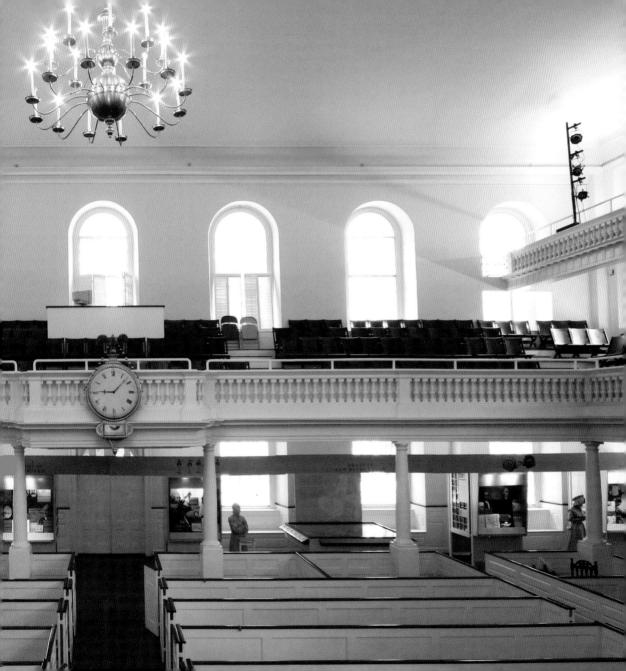

IT DOES NOT REQUIRE
a majority to prevail,
but rather an irate,
tireless minority keen
to set brush fires in
people's minds.

—Samuel Adams,
August 1, 1776

Tea from the Tea Party, Massachusetts
Historical Society

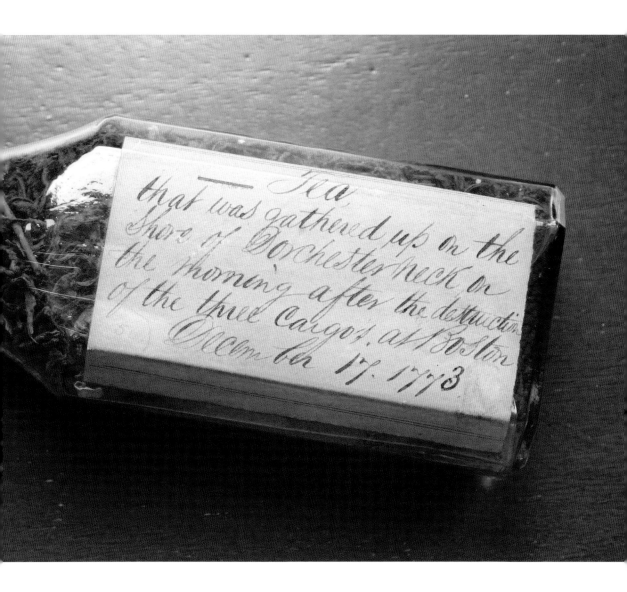

Tea, that was gathered up on the
Shore of Dorchester neck, on
the morning after the destruction
of the three Cargoes, at Boston
December 17. 1773

General Gage arrived to find he did not have the power to
govern Massachusetts. He and his troops held Boston,
but in the rest of the province people continued to govern
themselves. Samuel Adams had organized a communications network —
Committees of Correspondence—to keep other towns and colonies
informed of actions in Boston. Now Adams arranged for a meeting of all
colonies in a Continental Congress in Philadelphia. Adams, with his
cousin John and merchant John Hancock, went to Congress.

Suffolk County, its largest town occupied by British troops, held a con-
vention in Milton. The delegates insisted that Gage held power illegally.
Rather, they argued, the Massachusetts Charter, which authorized town
meetings and assembly elections, created the only legitimate government.
Throughout Massachusetts, other town meetings agreed with the Suffolk
Resolves. In Philadelphia the Adamses and Hancock presented the Suffolk
County argument for local control, against Parliament's arbitrary power.

[SAMUEL] ADAMS, I BELIEVE, HAS THE MOST THOROUGH understanding of liberty . . . as well as the most habitual, radical love of it, of any of them, as well as the most correct, genteel, and artful pen.

—John Adams, 1768

Statue of Samuel Adams, sculpted by Anne Whitney, in front of Faneuil Hall

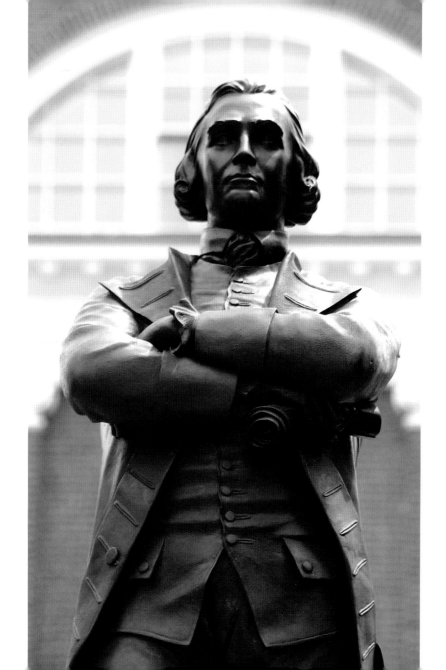

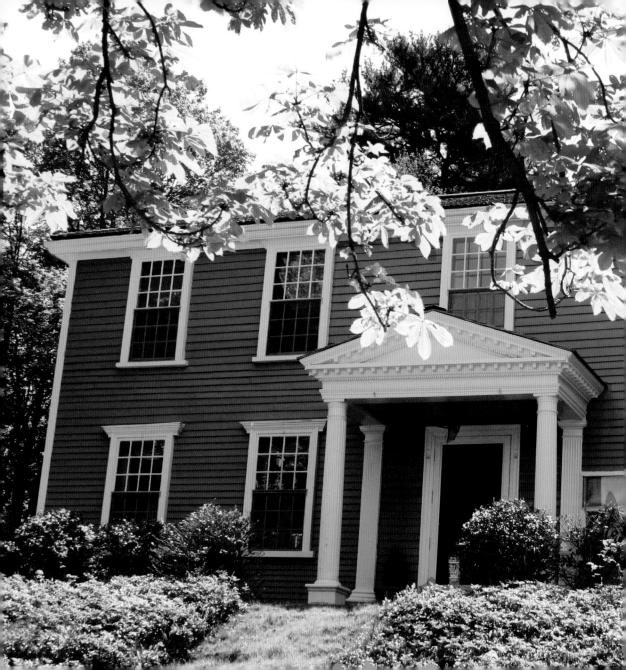

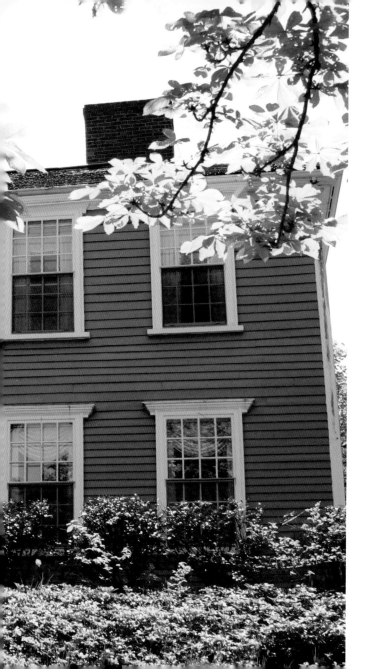

The Suffolk Resolves House,
Milton, site of a convention
of Suffolk County delegates

General Gage knew that the people of Massachusetts were stockpiling weapons and gunpowder. In the fall of 1774 he sent soldiers to seize gunpowder held in what is now Somerville. He also increased fortifications around Boston.

The British government authorized Gage to disarm the increasingly hostile local militias. On the night of April 18, he prepared seven hundred troops to march twenty miles west of Boston to seize weapons held in Concord. Gage also knew that Samuel Adams and John Hancock were in nearby Lexington, and that he could arrest them for treason.

Seven hundred soldiers cannot march in secret. From Old North Church a lantern flickered a signal that the British Regulars were mobilizing. Paul Revere rode from Charlestown, and William Dawes from Roxbury, to warn that the regulars were on the march. Revere and Dawes alerted messengers in other towns, who rode through eastern Massachusetts spreading news of the regulars' march.

When Gage's troops reached Lexington at dawn, that town's militia was assembled on the town green. The regulars fired, the Lexington militia

dispersed, and the troops continued their march to Concord. There, at the North Bridge, militia forces from throughout eastern Massachusetts had joined the Concord militia. Ordered by the regulars to disperse, these men held their ground. When the British opened fire, the militiamen fired back and kept firing.

Under heavy fire the British began a retreat. Militia forces continued to gather along the retreating line, shooting at the troops from behind houses, trees, and walls. At the end of the day Gage's troops were back in Boston—but surrounded. "Great numbers of the Rebels are in arms at Roxbury," a British lieutenant wrote, "and there has been no free communication with the Country this day." Gage wrote that the "whole Country was assembled in Arms with Surprizing Expedition, and Several Thousand are now Assembled about this Town threatening an Attack, and getting up Artillery."

Gage now had 6,500 men. Surrounding the town were 13,000 militia forces from as far away as New Hampshire, Connecticut, and Rhode Island, camped at Cambridge and Roxbury.

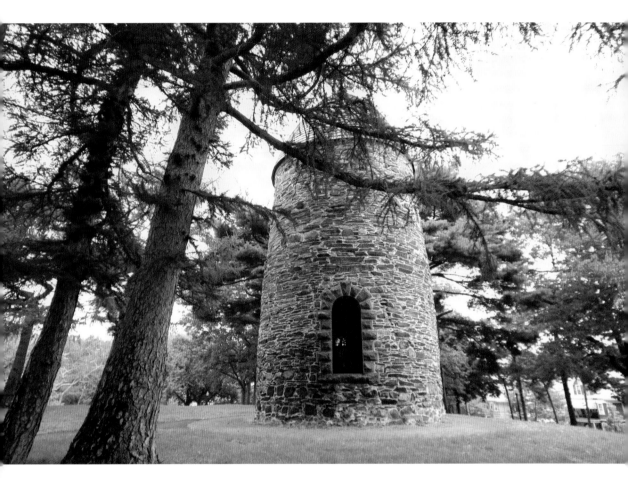

OUR TOWNS ARE BUT BRICK AND STONE, AND MORTAR AND WOOD. They, perhaps, may be destroyed. They are only the hairs of our heads. If sheared ever so close, they will grow again. We compare them not with our rights and liberties. We worship as our fathers worshipped, not idols which our hands have made.

—John Dickinson to Arthur Lee, April 29, 1775

Powder House, Somerville

I WAS SENT FOR BY DOCR. JOSEPH WARREN . . .
on the evening of the 18th of April, about
10 O'clock. . . .

—Paul Revere, *Memorandum*
on Events of April 18, 1775

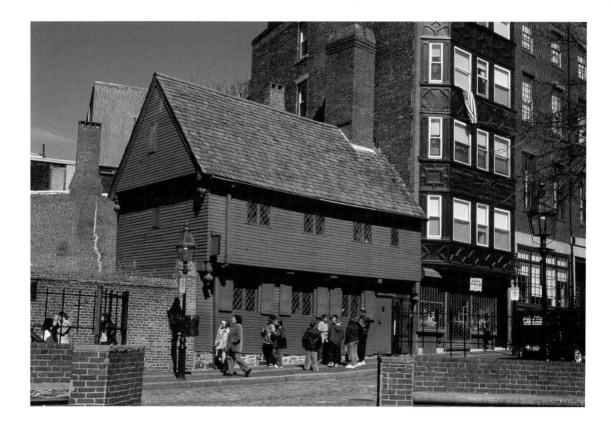

Paul Revere House, Boston's North End

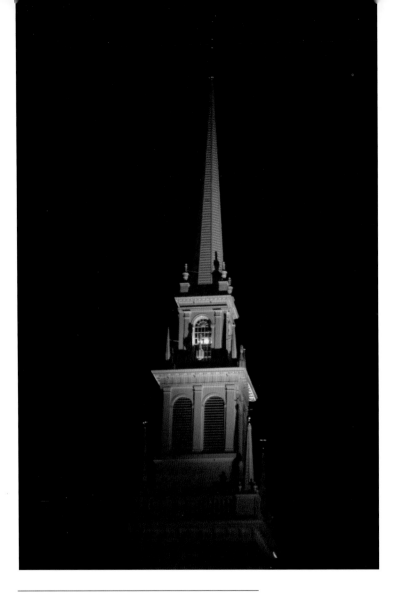

Lanterns in the belfry of Old North Church, Boston

BUT MOSTLY HE WATCHED WITH EAGER SEARCH

The belfry-tower of the Old North Church,

As it rose above the graves on the hill,

Lonely and spectral and somber and still.

—Henry Wadsworth Longfellow,

 "Paul Revere's Ride," 1860

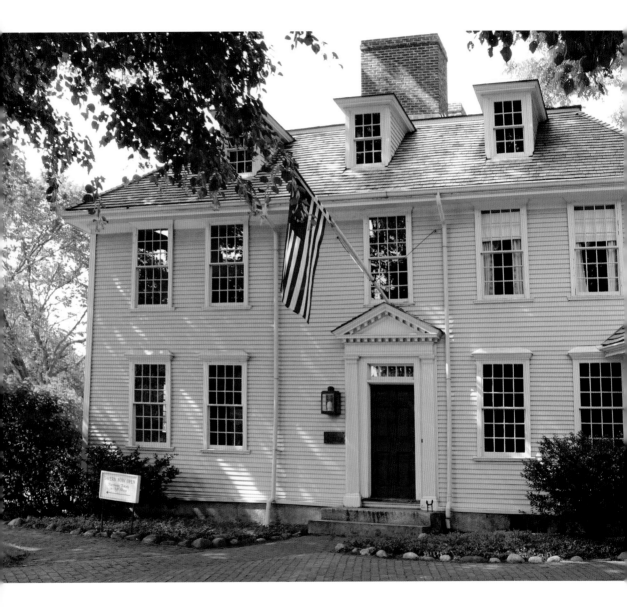

I SET OFF, IT WAS THEN ABOUT 11 O'CLOCK, the moon shone bright. I had got almost over Charlestown Common, towards Cambridge, when I saw two officers on horse-back, standing under the shade of a tree, in a narrow part of the road. I was near enough to see their holsters and cockades. One of them started his horse towards me, the other up the road, as I supposed, to head me, should I escape the first. I turned my horse short about, and rode upon a full gallop for Mistick Road. He followed me about 300 yards, and finding he could not catch me, returned. I proceeded to Lexington, through Mistick, and alarmed Mr. Adams and Col. Hancock.

—Paul Revere, *Memorandum on Events of April 18, 1775*

Buckman Tavern, Lexington, where militiamen gathered before the battle on the Green

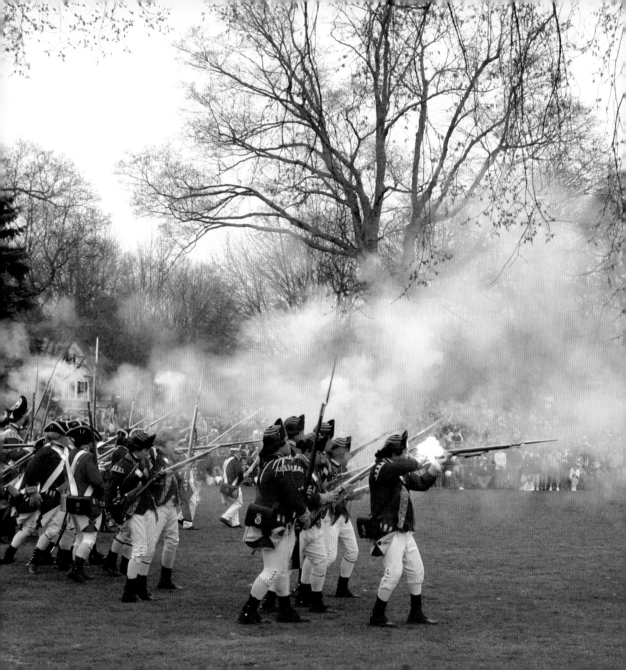

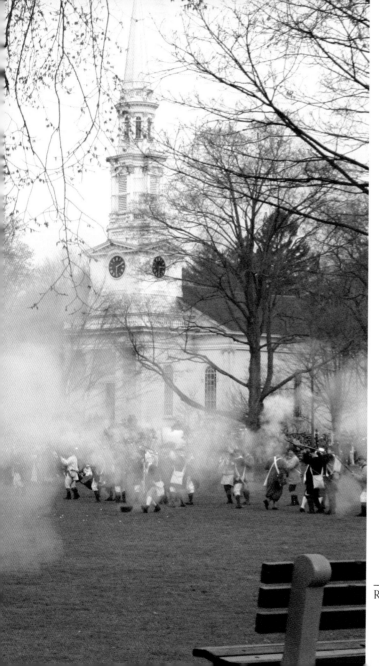

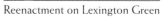

Reenactment on Lexington Green

STAND YOUR GROUND!
Don't fire unless fired
upon! But if they want
to have a war, let it
begin here!

—Captain John Parker,
Lexington Green,
April 19, 1775

Statue of Lexington Minuteman by Sir Henry Hudson Kitson, Lexington Green

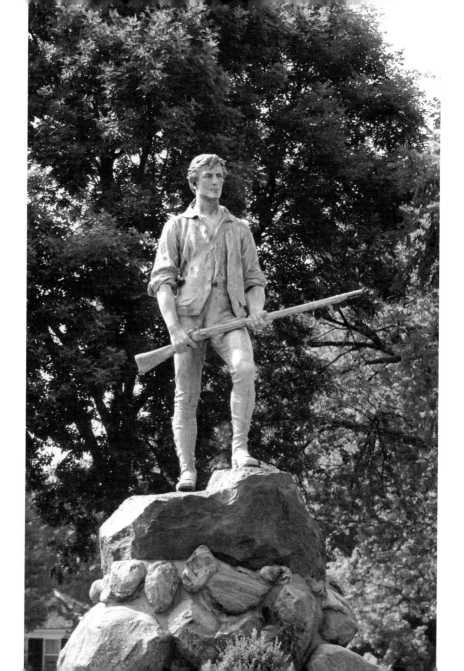

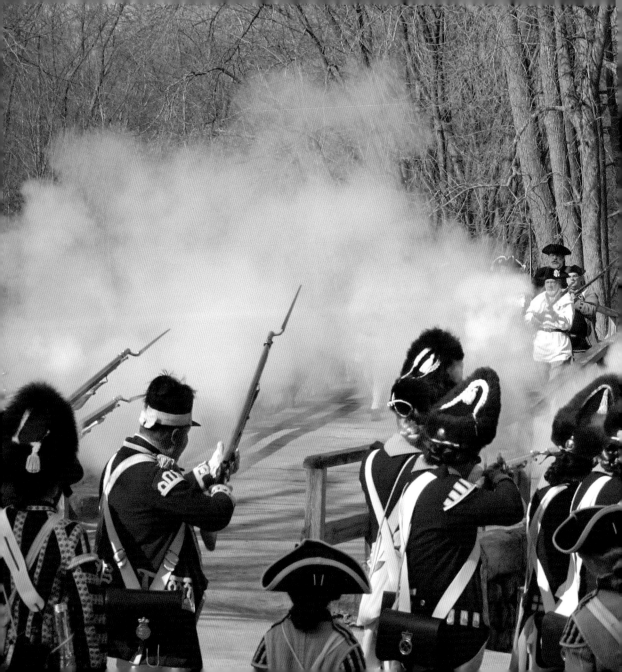

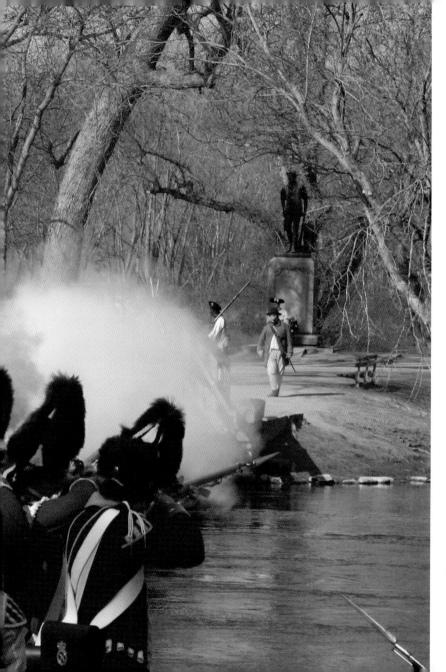

Reenactment at North
Bridge, Concord

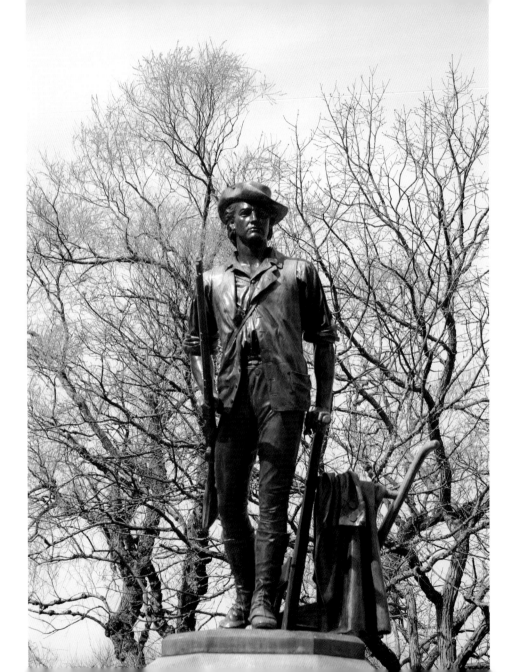

BY THE RUDE BRIDGE THAT ARCHED THE FLOOD,

Their flag to April's breeze unfurled,

Here once the embattled farmers stood

And fired the shot heard round the world.

—Ralph Waldo Emerson, "Concord Hymn,"
1836

Statue of Concord Minuteman by Daniel Chester French, North Bridge

NUMBERS OF ARMED MEN ON FOOT AND ON HORSEBACK, were continually coming from all parts guided by the fire, and before the Column had advanced a mile on the road, we were fired at from all quarters, but particularly from the houses on the roadside, and the Adjacent Stone walls.

—Lt. Frederick MacKenzie, British Twenty-third
 Regiment, April 19, 1775

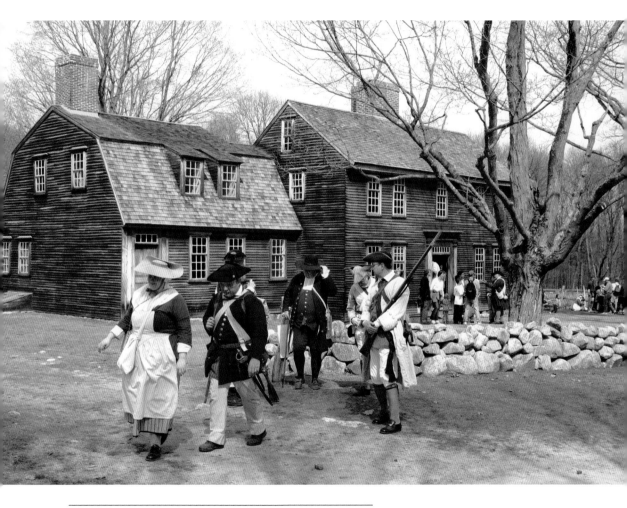

Hartwell Tavern, Lincoln, scene of fighting along the Battle Road

age tried to disperse the gathered militia forces in June 1775. He would take Charlestown and then sweep through Cambridge and Roxbury, dispersing the poorly trained men. Before his troops could cross the Charles River, the Massachusetts troops fortified the top of Breed's Hill in Charlestown. On the morning of June 17, 2,000 British soldiers landed at Charlestown and began to march up Breed's Hill. When they reached the top, the Americans opened fire, cutting down lines of British soldiers. The British retreated but resolved to try again. Cannon from Copp's Hill in Boston, and the British ships in the harbor and river, smashed into Charlestown. Again the British forces marched up the hill. Again the heavy close-range fire sent them down.

Toward the end of the day, the British tried a final assault. This time, with the American forces nearly out of ammunition, the British captured Breed's Hill and pushed on to take Bunker's Hill beyond it. But the Americans who remained in the fortifications fought on with bayonets, allowing most American forces to escape back into Cambridge. A heavy loss for the Americans was the death of Dr. Joseph Warren, leader of the Massachusetts government. Warren had been commissioned a general, but as his commission had not formally arrived, he served at Bunker Hill as a private. The British suffered heavier losses: more than a thousand lay dead or dying on the slope of Breed's Hill. "I wish we could sell them another hill at the same price," said American Nathanael Greene.

THE DAY; PERHAPS THE DECISIVE DAY
is come on which the fate of
America depends.

—Abigail Adams to John Adams,
June 18, 1775

Statue of Col. William Prescott by William W. Story, Bunker Hill Monument, Charlestown

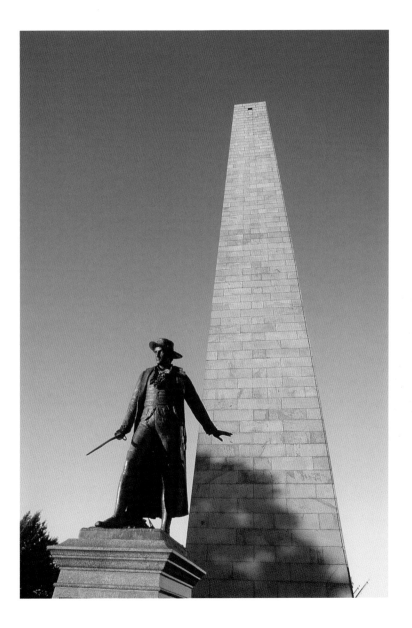

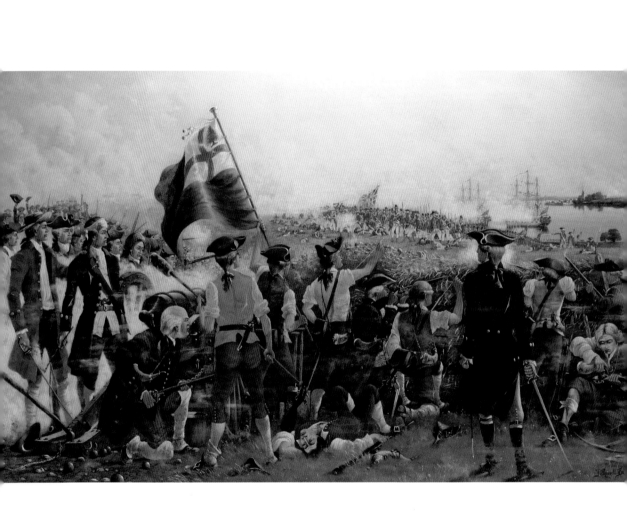

The Battle at Bunker Hill by F. Russell Bates, Museum of the Ancient and Honorable
Artillery Company of Massachusetts, Faneuil Hall

MEN, YOU ARE ALL MARKSMEN—
don't one of you fire until you
see the white of their eyes.

—Israel Putnam, at Breed's Hill,
 June 17, 1775

GOOD DOCTR. WARREN. "GOD REST HIS SOUL,"
I hope he is Safe in Heaven! Had many of
their Officers the Spirit & Courage in their
Whole Constitution that he had in his little
finger, we had never retreated.

—Samuel Blachley Webb, Lt., Connecticut
 Militia, June 19, 1775

Statue of Dr. Joseph Warren by Henry Dexter, Bunker Hill Monument

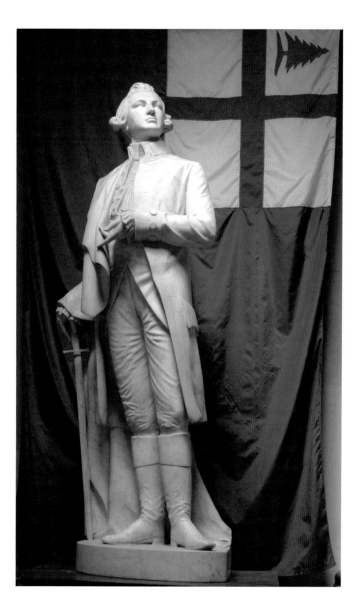

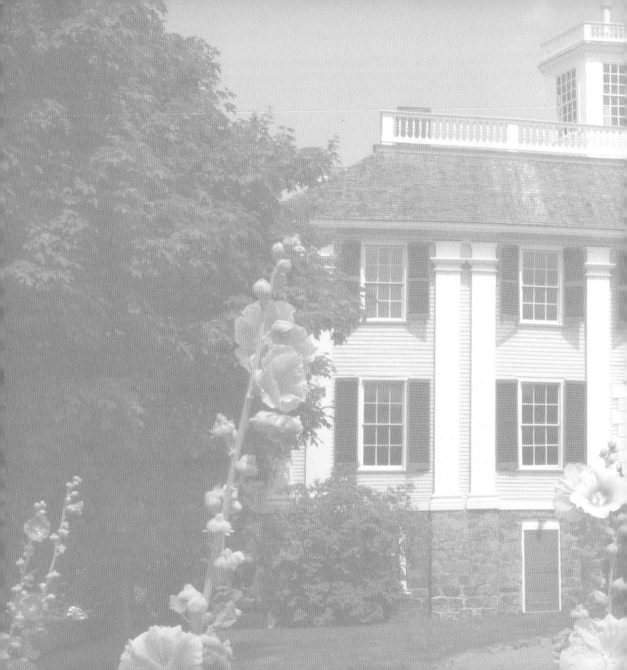

George Washington arrived on July 2, 1775, to take command of the disorganized but effective American troops. John Adams had nominated Washington to lead the Continental Army, which he would create out of the New England militia forces he found in Cambridge and Roxbury. Washington mustered his forces on Cambridge Common, using Harvard College and Cambridge's Christ Church as barracks, and the nearby Vassal estate as his headquarters. As he trained his troops, Washington planned ways to force the British out of Boston.

From Prospect Hill in Somerville and Fort Hill in Roxbury, Washington and his officers watched the British in Boston. General John Thomas made his headquarters in Roxbury's First Church parsonage, and the Massachusetts Sixth Regiment occupied the elegant Shirley estate, overlooking Boston across the South Bay. From Cambridge, Martha Washington wrote a friend, "I just took a look at pore Boston & Charlestown. . . . thare seems to be a number of very fine Buildings in Boston but god knows how long they will stand; [the British] are pulling up all the warfs for firewood."

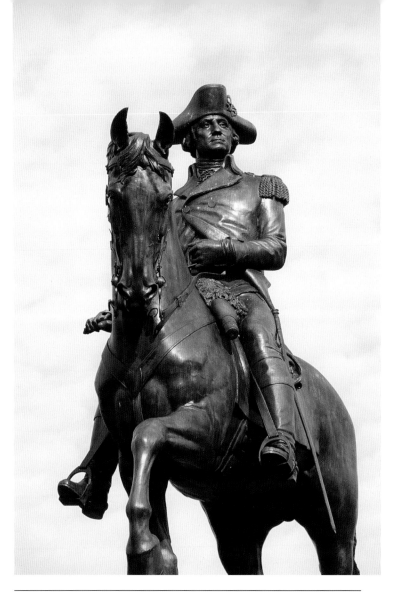

Statue of Gen. George Washington by Thomas Ball, Boston Public Garden

I WAS STRUCK WITH GENERAL WASHINGTON. You had prepaired me to entertain a favorable opinion of him, but I thought the one half was not told me. Dignity with ease, and complacency, the Gentleman and Soldier look agreeably blended in him.

—Abigail Adams to John Adams,
 July 16, 1775

PROCEED, GREAT CHIEF, WITH VIRTUE ON THY SIDE,

Thy ev'ry action let the goddess guide.

A crown, a mansion, and a throne that shine,

With gold unfading, WASHINGTON! be thine.

—Phillis Wheatley, "To his excellency General
 Washington," 1775

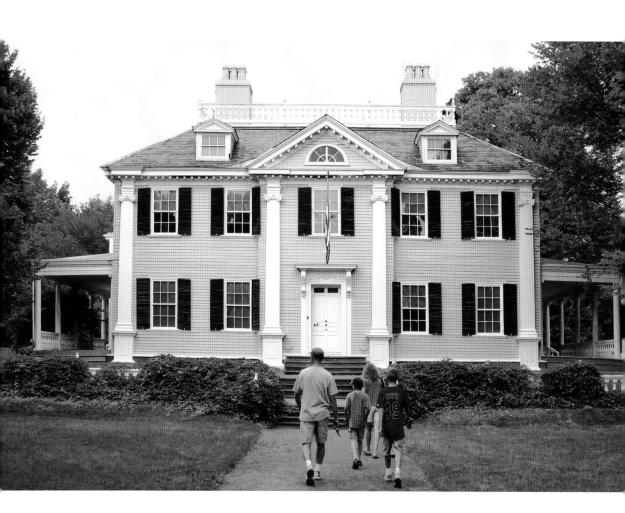

Vassal Estate (now Longfellow House), George Washington's headquarters in Cambridge

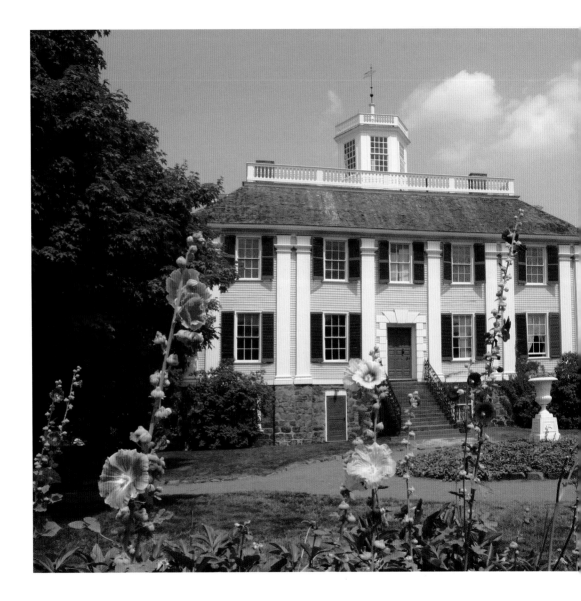

AUSPICIOUS HEAVEN SHALL FILL WITH FAV'RING GALES,

Where e'er Columbia spreads her swelling Sails:

To every Realm shall Peace her Charms display,

And Heavenly Freedom spread her golden Ray.

—Phillis Wheatley, "Liberty and Peace," 1784

Shirley-Eustis House, Roxbury, quarters for the Massachusetts
Sixth Regiment during the siege of Boston

George Washington noted the high ground of Dorchester Neck, pastureland commanding views of Boston, Castle Island, and the British fleet in the harbor. General William Howe, who relieved General Gage after the Battle of Bunker Hill, had neglected to fortify Dorchester Neck. Washington saw an opportunity.

When Fort Ticonderoga, the poorly manned but well-armed British garrison on Lake Champlain, fell to Ethan Allen's Vermont militia and a force under Benedict Arnold, Washington sent Henry Knox, an earnest Boston bookseller, to secure the Fort's 80 cannon. Knox spent the winter of 1775–76 bringing the cannon by sled and oxcart across Vermont and Massachusetts. He delivered them to Washington in February. By March 4, Washington's men had built fortifications on Dorchester Neck, putting the British forces and fleet within range of his guns. Howe tried to storm Dorchester Heights, but a sudden squall dispersed his attack.

Howe could no longer hold Boston. On March 17, 1776, the British army, which had arrived eight years earlier to keep peace, left Boston forever.

Washington and his army left for New York, believing the British were also headed there. By this time, John Adams had persuaded Congress to declare independence, and he nominated Thomas Jefferson to write a Declaration of Independence. On July 18, 1776, former Sons of Liberty leader Thomas Crafts climbed onto the balcony of the Old State House to read the Declaration to the people of Boston.

John Adams wrote a Constitution for the Commonwealth of Massachusetts in 1779, creating a three-branch government, with a governor elected directly by the people, an assembly to represent the people of the towns, and a judiciary to ensure impartial justice. Under this Constitution—now the oldest written constitution still functioning in the world—the people of Massachusetts continue to govern themselves.

MAR 17. ST. PATRICK'S. THE PROVINCIALS are throwing up a Battery on Nook Hill in Dorchester Neck which has occasioned much Firing this night. This morning the Troops evacuated the Town & went on board the Transports at & about Long Wharff. . . . About Noon Genl Putnam & some troops came into Town to the Great Joy of the Inhabitants that Remained behind.

—John Rowe, Boston Merchant,
 Diary, 1776

Dorchester Heights, where patriot cannons forced the British evacuation of Boston

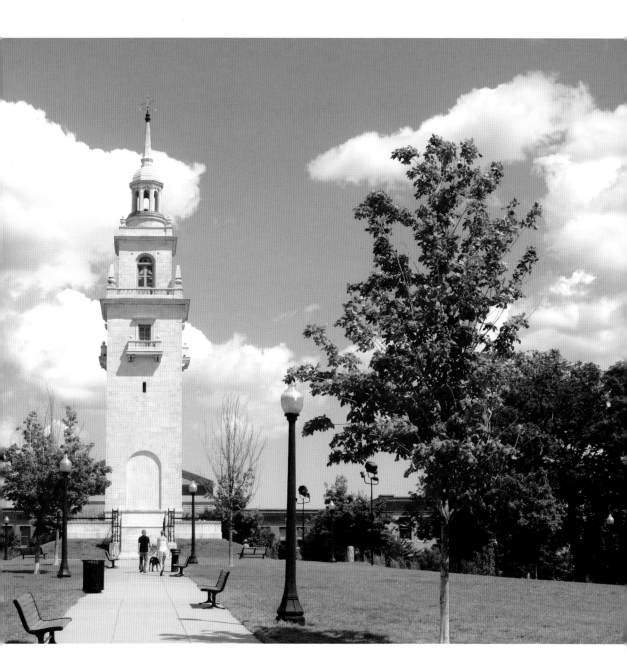

I LONG TO HEAR THAT YOU HAVE DECLARED AN INDEPENDENCY—
and by the way in the new Code of Laws which I suppose it will be
necessary for you to make I desire you would Remember the Ladies,
and be more generous & favourable to them than your ancestors. Do
not put such unlimited power into the hands of the Husbands.
Remember all Men would be tyrants if they could.

—Abigail Adams to John Adams, March 31, 1776

Abigail Adams, Boston Women's Memorial by Meredith Bergmann, Commonwealth Avenue

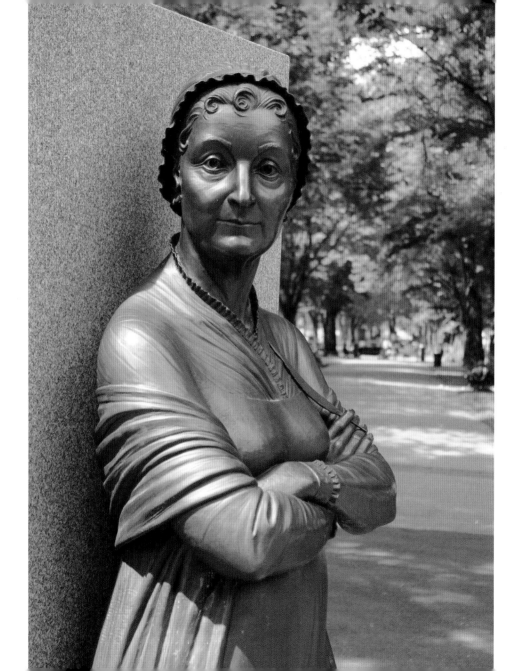

ACKNOWLEDGMENTS

SPECIAL THANKS TO ROBERT GOLD AND SUE GOGANIAN OF THE BOSTONIAN SOCIETY/OLD State House Museum; Paul Tiemann, Eastern National Park & Monument Association; the staff at the Adams National Historical Park, Quincy; John McCauley, the Ancient and Honorable Artillery Museum, Faneuil Hall, Boston; National Park Service staff at Bunker Hill and Dorchester Heights; Christine Sherman, the Old South Meeting House; the Castle Island Association; the State of Massachusetts; Andrea Taaffe, the Shirley-Eustis House, Roxbury; Jim Shea, Longfellow National Historic Site, Cambridge; Edie Clifford of the Milton Historical Society, which owns and maintains the Suffolk Resolves House, Milton; the staff at Minute Man National Historical Park; Anne E. Bentley, the Massachusetts Historical Society; and Julia Mize and Michael Bradford of the Boston National Historical Park, Downtown District.

Thanks also to publisher Webster Bull for his continued support and assistance; to series editor Andrew Borsari; and to Penny Stratton, Anne Rolland, Russell Scahill, Peter Blaiwas, Benjamin Jenness, and everyone else who helped produce the book.

Front cover photo: Reenactment at North Bridge, Concord
Back cover photo: Faneuil Hall, Boston

Photo by Monika Dräger

ULRIKE WELSCH, international photographer, immigrated from Germany to the United States in 1964. She was the first female photojournalist on the staffs of the *Boston Herald* and the *Boston Globe*, where she provided award-winning images. Since 1981 she has compiled a photographic stock library, working from her home in Marblehead, Massachusetts. She is the author of eight books, including *Boston Rediscovered* (Commonwealth Editions, 2002) and *Boston's North Shore* (2003).

ROBERT J. ALLISON chairs the History Department at Suffolk University. He received his Ph.D. from Harvard University. The author of *A Short History of Boston* (Commonwealth Editions, 2004), he lives with his family near Dorchester Heights in South Boston.

REVOLUTIONARY SITES OF GREATER BOSTON

1. Suffolk Resolves House (*Milton*)

2. Somerville Powder House

3. Lexington Green &
 Buckman Tavern

4. North Bridge (*Concord*)

5. Hartwell Tavern (*Lincoln*)

6. Bunker Hill Monument

7. Shirley-Eustis House (*Roxbury*)

8. Dorchester Heights

9. Castle Island

10. John Adams Birthplace
 (*Quincy*)